YUSEF KOMUNYAKAA

RACHEL BLISS

NIGHT ANIMALS

QUARTERNOTE CHAPBOOK SERIES #18

SARABANDE BOOKS
Louisville, KY

Library of Congress Cataloging-in-Publication Data
Names: Komunyakaa, Yusef, author.
Title: Night animals / by Yusef Komunyakaa.
Description: First edition. | Louisville, KY : Sarabande Books, [2020]
Identifiers: LCCN 2019032534 (print) | LCCN 2019032535 (ebook) | ISBN
 9781946448583 (paperback ; alk. paper) | ISBN 9781946448590 (ebook)
Subjects: LCGFT: Poetry.
Classification: LCC PS3561.O455 N54 2020 (print) | LCC PS3561.O455
 (ebook) | DDC 811/.54--dc23
LC record available at https://lccn.loc.gov/2019032534
LC ebook record available at https://lccn.loc.gov/2019032535

Exterior design by Alban Fischer.
Interior design by Danika Isdahl.

Manufactured in Canada.
This book is printed on acid-free paper.
Sarabande Books is a nonprofit literary organization.

This project is supported in part by an award from the National Endowment for the
Arts. The Kentucky Arts Council, the state arts agency, supports Sarabande Books
with state tax dollars and federal funding from the National Endowment for the Arts.

CONTENTS

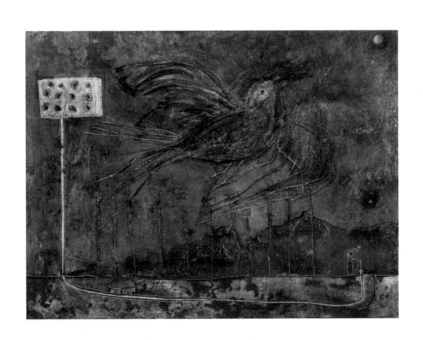

THE BLUE HOUR

A procession begins in the blue-
 black gratitude between worlds,
& the Rebirth Brass Band
 marches out of what little light
is left among the magnolia blooms.
 Step here, & one steps off
the edge of the world. Step there,
 & one enters the unholy hour
where one face bleeds into another
 as a horse-drawn buggy
rolls out of the last century,
 & the red-eyed seventeen-year locust
grows deeper into the old, hushed soil.
 Lean this way blue insinuation
takes over the body. Step here,
 & one's shadow stops digging its grave
to gaze up at the evening star. Or,
 at this moment, less than a half step
between day & night, birdhouses
 stand like totems against the sky.

A flicker of wings & eyes,
mockingbirds arrive with stolen songs
& cries, their unspeakable lies & omens
as if they are some minor god's
only true instrument & broken way
onstage in the indigo air.

They come with *uh-huh* & *yeah*,
a few human words, to white boxes
on twelve-foot poles,
to where each round door-hole
is a way in
& a way out of oblivion.

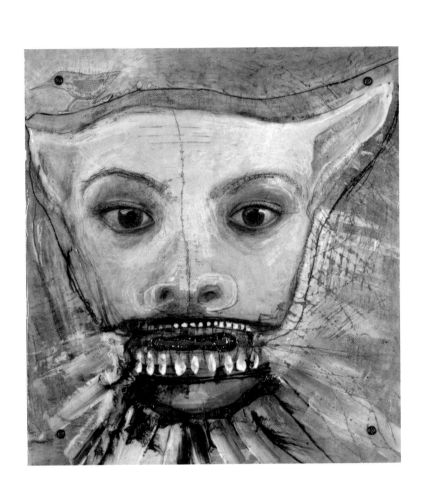

NIGHT

She crawls to the edge
on bright paws, to where humans come
to argue with gods
as the lampblack hours fill up
with the scent of animals.

The horizon is a strand of barbed wire
shadows shimmy under to look
death in the eye,
quivering like a seam of flesh
unzipping earth from sky.

Her quietness is almost vegetable.
She owns light & darkness.
The unsaid lingers—twofold
& then threefold—her great head
beckoning halfway across the abyss.

She edges so close
her skin is metaphysical,
her brain a hive,
a hum,
a lantern with eyes
printed on wings.

TREE GHOST

There's a rush, a rustle
among branches of a redwood,
& then mutable silence rushes in
like after a fight or making love.
The wings settle. The third eye
blindfolded. Hunger always speaks
the same language. Branches shudder
overhead, & the snowy owl's wingspan
seems to cool off the August night
with a breathing in & breathing out.

I close my eyes & can still see
the three untouched mice dead
along the afternoon footpath.
The screeching nest is ravenous.
The mother's claws grab a limb.
Now, what I know makes me look down
at the ground. I can almost feel
how the owl's beauty scared the mice
to death, how the shadow of her wings
was a god passing over the grass.

NIGHT SONG

Black cricket, caught in one gear on the cusp,
nibbling at an edge of the firmament,

you are an afterthought of hunger & belief
at twilight, driving the stars ad nauseam.

So, you think you know loneliness, huh?
Are you hiding beneath a stone, little coward,

or clinging to a dead reed? Your song is the only
evidence you're here, a loop of postmodern jive,

the keening of a lonely string across bridge & limbo.
Joy. Woe. A drop of awe craves the lowest note

in the tall grass. The night says, Don't pity
the one tuned by obsession, this old begging.

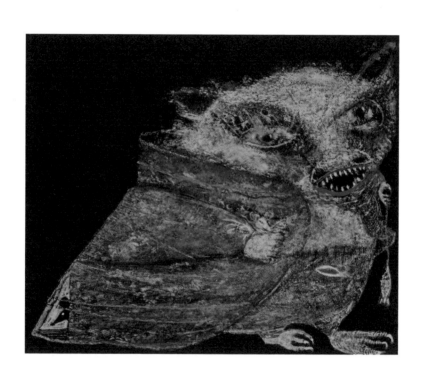

FLYING FOXES AT TRANSIT OF VENUS

They hang upside down,
half dreams of earth above
& sky below. The succulent
nectar & blossoms of night's
harvest ferment in bellies
pale & tight as bloated drums
or bulbous gourds. No wonder
these masters of drunk acrobatics
depend on the old faith of nomads.
Lords of antigravity, they copulate
this way also, gripping branches
to shake down a storm of berries
falling like hail. They mumble
the first word going back eons
now summoning them awake.

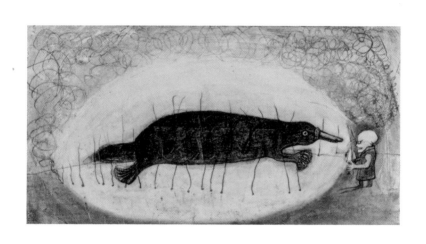

SEVERAL MYSTERIES OF THE PLATYPUS

She tries to hide in a swish of wet grass
because she remembers the first man
like a wound, an old scar, a howl
in the hush. Her skin is too tough
for the marketplace. Otherwise,
she would've fallen under a bullet
or knife. She came from an old world,
a prototype, the first chimera
pieced together by a prankish god
that first moment of light
seeping from the cave,
an oath written on her back
by the edge of a flood. Before
she slipped from the egg, she knew
a human face could make her heart
explode into a clutch of stars.

THE LEOPARD

She feels the shape of another animal
three trees ahead & raises her left front paw.
Dew trembles on each blade of grass
as a snake uncoils among the leaves.
She's a goddess in a world mastered
by repetition & unearthly cadence,
pacing off light hidden in darkness.
She eases down her right paw,
slow as coming to an answer
of the oldest unspoken question.
The prey lifts its sluggish head,
listening for a falling star,
a river running over stones,
& then returns to the hare
half-eaten beside a blooming hedge.
A hundred doors spring open.
A raised paw descends skillfully,
softly. The grass rises behind her.
The mitigated laws of kingdom,
district, & tribe do not matter here.
She crouches down inside her
longing, one great leap away
from a wild, simple knowledge.
Sinew, muscle, gratitude—she—
& then to ride another animal
down to growl, tussle, gristle,
& blood-lit veins on leaves left
quivering in the passing night.

SNOW TIGER

Ghost sun half-
hidden, where did you go?

There's always a mother
of some other creature
born to fight for her young.

But crawl out of your hide,
walk upright like a man,
& you may ask if hunger is the only passion
as you again lose yourself
in a white field's point of view.

In this glacial quiet
nothing moves except—
then a flash of eyes & nerves.

If cornered in your head by cries from a cave
in another season, you can't forget
in this landscape a pretty horse
translates into a man holding a gun.

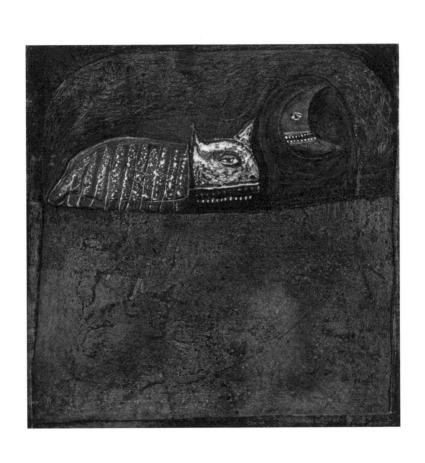

NIGHT SCENE

The orangey-yellow eyes of magpies
cluster in a sweet gum on a street corner.
Animals know what's going to happen
a day before the promise tree questions
dumb skies. A jade cicada answers.
Everything is muted except the eyes
at two a.m. Three or four alley cats
outlined on gray stillness, pace off
shadows, hunting any moving thing.
Birds rise in the shape of the tree.
As if to hide from what he feels
the insomniac sees a new world
through the merciless eyeholes
cut into his cardboard box.

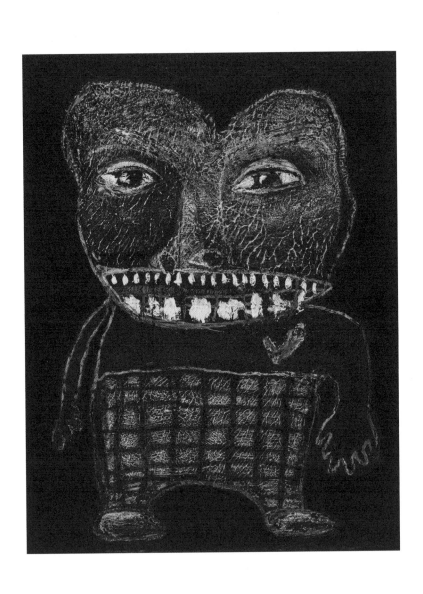

FROM A DISTANCE

What does a small room look like
with two drunken men dancing
with each other, one taking the lead
& the other following, their cowboy shirts
a blur? We can see their laughter
though we can't hear it. The faint sound
of a harmonica colors the walls do-si-do.

If they were fighting, would the hues
change into more blues & grays,
or more reds & greens, or twelve
nightmares between somber & sobering up?
The two big men in their cowboy boots
two-step to the sound of things falling.

TONIGHT

In Yellowstone wolves
circle a grizzly & her cub
eating a kill. Airy mist
blinds the wintry brain,
& she turns, chasing all six.
There's a standoff beneath
a quarter moon full of blood.
Only a human would know
which one wins this tussle
this side of several eternities
on the edge of springtime.

On another side of the world
a wolf paces the edge of town.
Farmers, gardeners, & Girl Scouts
stumble out of the woods once
or twice every year, shouting
in tongues about a spotted tiger
following them along a creek bed
around a high barbed-wire fence
as sheep cower, up a stony slope,
to a lunar graveyard of tall anthills.

NIGHT-BLOOMING CEREUS & FAÇADE

I can't take my eyes off the nude
in a third-floor window at one a.m.
Where she is it is already day
in Copenhagen & Atlantis,
& I'd bet mystery against my life
she's listening to "Bouncing with Bud."
Swaying to fingers up & down the keys,
she's at the edge of something grand
now fallen into decay & shambles.

I don't think she's an ad seen through the window
of a façade, but she could be a painter's model
taking a break from sitting in a single pose
for hours, in dialogue with shades of red,
begging Bud's shadow not to limp away
wounded by nightsticks. I wonder if she knows
blooming has filled up the room & left her lonely
as I am tonight beneath a handful of cosmic dust,
a boarded-up front door still guarded by two lions.

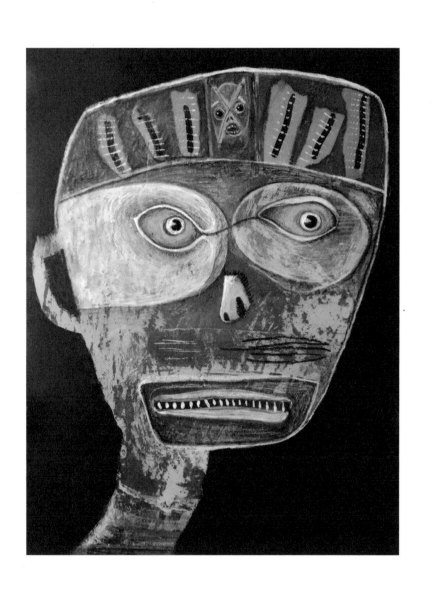

ANOTHER KIND OF NIGHT

Slowly, the remembered trees, a nine-hundred-year-old sky,
the call of birds, a mamba snake snoozing beside a stone,

a mask tall as a man an hour after sunset,
jackals holding a ceremony at the edge of a lake,

it all fades into rancor. But my own face is still a boy's,
losing its features down there where everything is one

godforsaken animal wounded in the nameless dark.
All the faces are one constellation where the dead

interrogate the living. The motion of the sea beneath—
god of moonlight, god of sharks patrolling the schooner,

& god of laughter on the deck. Hyenas on a hilltop,
are you still trying to tell me something about mercy?

In this other night riding the trade winds, the waves
underneath a creaking eternity, we are nothing

but cargo. Moans in the belly of a writhing leviathan
wind-tossed, the sails torn down to tatters, beached up

on white sand stretching out against sky for centuries,
seagulls calling to birth cries in the new world.

NIGHTHAWKS

They scissor edges of twilight, cutting
black shapes into sky. The wet silver
of quick wings open against eternity,
as if to erase an end with a beginning.

NIGHTRIDERS

In the rearview mirror of a pickup turning a corner
peaked heads throng around a burning cross.

The fleshy scent of magnolia rekindles the years,
& a single night cannibalizes a century of blooms.

In a deep vista of scrub oak a hoot owl names
the lost ones, growing into the never-heard-of.

Silence lights flesh & myth till they're all one
song of blood bloating a crescent till dogwood

branches sag, & ugliest of the four horsemen
languishes in medieval garb, feet in a noose.

BLIND FISH

Caught here in your limestone cave,
lost in a limbo of slow water torture,
for you, each day is always night.
Condemned to circle contours of a god's
state of mind, all pale swimmers
in this light are a deck of cards
shuffled by a pro. I back away
& you come forth like falling
leaves, & when I come closer,
you ease away. How do you see
into darkness? I wonder if you know
the shape of gone, of never been born.

NIGHT OF THE ARMADILLO

You huddle into a shield or breastplate,
a whisper in the dark summoning your kin
one by one along the frontier. In your kingdom,
errant knight of undergrowth, even in your gut
fear, you're always on the verge of a new border
or at the edge before crossing into the interior
of false prophecies. Desert blooms or berries
fall into marshy hush. Around a sharp curve
planetary lights spring out of nothingness.
How did you go wrong? With only blind faith
& a dead star left in your eyes, where's North
America? You've been around eons,
not knowing when you've left one age
& entered another, but I found your Olympus
of foolish odds in the modern world.
Lovers in cars, delivery trucks make leaves
tremble along the roadside. If you know this,
little suitcase of guts & nails,
you are still alive,·
even with your broken hinges.

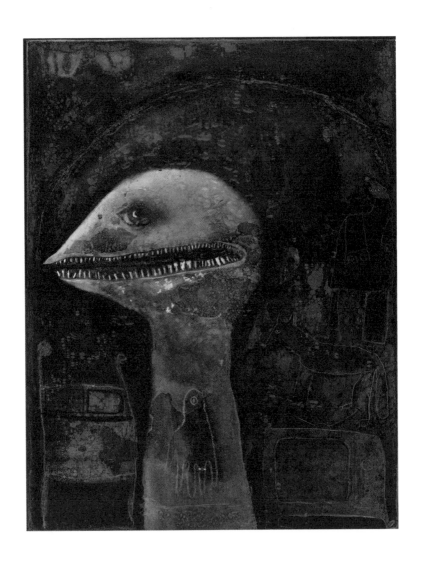

SELF-PORTRAIT AT NIGHT

Sister, tall & strong as a column,
you become whomever you wish.
You are a fox. Now, a bird.
Your third eye gazes at me
from left side of your face,
& something makes me ask,
Do your monsters still love
to death their labyrinth?
Your paper hands are accidentally
misshaped on purpose. You look
like someone who would use a stone
as a pillow, identical twin of granite
smoke in my psyche. Teeth sharp
as a zipper, you're always eating cloth.
You know there's never a shortcut
to melon & bread on a kitchen table.
A city map is etched on your skin,
but in almost every starless nocturne
there's a second path to the underworld.

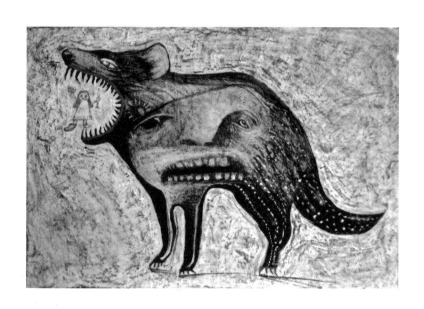

A NOTE ON TASMANIA

He yawns to show his teeth
to remind them of his story
on this nightly hill of tussock
before the rainbow serpent
quaked in its long-ago cave.

Where's the tiger, the wolf?
Almost old as minerals here,
he rears up on his hind legs
to make them mouth invectives
brought for him on their ships.

He fought since the first
gangplank raised & fell in sea fog.
Can't they see he's the only angel
stranded this side of the equator?
Though there's a little white flag

of surrender stamped on his chest
he's still here. Something unloved
now tries to devour his character,
but they've seen a fierce shadow
run off to hide beneath the stadium.

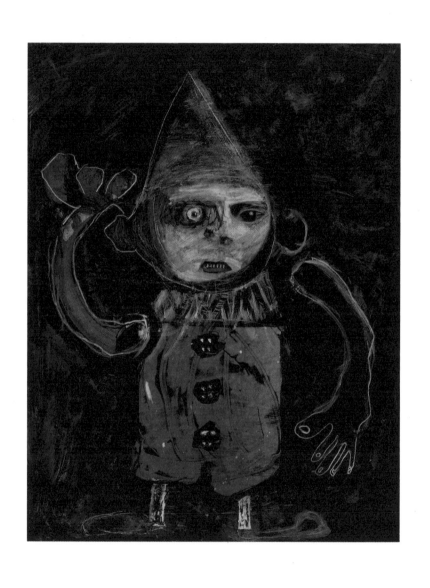

AYE-AYE

His head pivots to see
what he's running to & from—gone

but still coming toward you, he comes
into the world, giving a middle finger

to the sky gods. A whole face gazes
big-eyed, a breathing compass

gauging how life looks at death.
A kingdom floats in his skull.

This all-knowing, espial seer
fits into a vagabond's coat pocket.

When he sidles up, so profound
& immutable, no one can live

holding a scream inside himself,
hoping to hide from a last curse.

NIGHTLY

Thrush in the eaves. Wind-up toy
found behind a bedroom door. Ghost
son at four a.m., white miniature guitar.
At this hour, we still cavort daily.

CROSSING THE DIVIDE

The city at three a.m. is an ungodly mask
the approaching day hides behind
& from, the coyote nosing forth,
a muscle memory of something ahead,

& a fiery blaze of eighteen-wheelers
zooms out of the curved night trees,
along the rim of absolute chance.
A question hangs in the oily air.

She knows he will follow her scent
left in the poisoned grass & buzz
of chainsaws, if he can unweave
a circle of traps around the subdivision.

For a breathy moment, she stops
on the world's edge, & then quick as that
masters the stars & again slips the noose
& darts straight between a sedan & SUV.

Don't try to hide from her kind of blues
or the dead nomads who walked trails
now paved by wanderlust, an epoch
somewhere between tamed & wild.

If it were Monday instead of Sunday
the outcome may be different,
but she's now in Central Park
searching for a Seneca village

among painted stones & shrubs,
where she's never been, & lucky
she hasn't forgotten how to jig
& kill her way home.

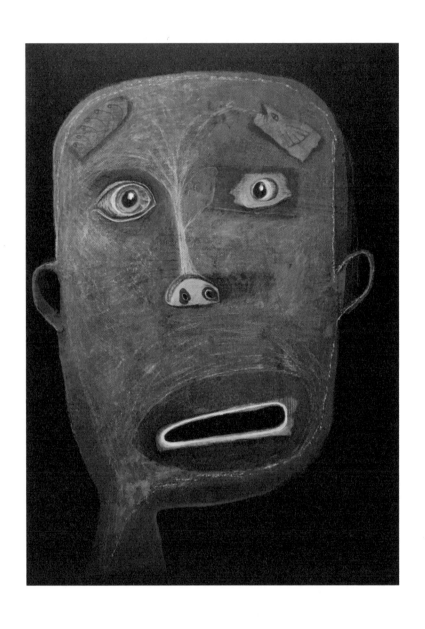

NIGHT GIGGING

A three-pronged spear waits for a bullfrog
to sing bass from the weedy millpond.

A silhouette lingers, cleaved from the kneeling man,
back to hunger & simple philosophy of the spheres,

how dirt begs for a seed to work into a thick root
to pry up the foundation of a heavy wooden bridge.

There's a ghost poised between free will & the gig,
waiting for the song, the blink of an eye

in a gully of bloomy thorns. Martian light
on tall grass guides the practiced instrument.

Hold. Oh. Now, go. It calls with open vowels,
looping through a froggy nighttime

domain, a knot in the throat, & yeah,
cinching up the bloated moon in a bag.

ACKNOWLEDGMENTS

Grateful acknowledgement is made to the following publications, in which some of these poems originally appeared: *Callaloo, The New Republic, The New Yorker, The Paris Review, Poetry, Smartish Pace, TriQuarterly,* and *The Village Voice,* as well as *Improbable Worlds: An Anthology of Texas and Louisiana Poets,* edited by Martha Serpas.

THE AUTHOR

Yusef Komunyakaa's books of poetry include *Dien Cai Dau*, *Neon Vernacular*, for which he received the Pulitzer Prize, *Talking Dirty to the Gods*, *Warhorses*, *Emperor of Water Clocks*, and *Everyday Mojo Songs of Earth* (forthcoming from FSG in 2020). His honors include the William Faulkner Prize (Université Rennes, France), the Ruth Lilly Poetry Prize, and the 2011 Wallace Stevens Award. His plays, performance art and libretti have been performed internationally and include *Saturnalia*, *Wakonda's Dream*, *Testimony*, and *Gilgamesh*. He teaches at New York University.

THE ARTIST

Rachel Bliss is a Philadelphia-based artist whose work depicts a visual innuendo that is as surreal as the environment she is a part of. Since 1991, Bliss has exhibited in galleries and museums including The Philadelphia Museum of Art, James A. Michener Museum, The Pennsylvania Academy of the Fine Arts, Coombs Contemporary Gallery in London and The Alternative Museum in New York. Bliss' art has been commissioned by and featured in numerous publications including *The New York Times*, *The Village Voice*, Penguin Books, and *The New Yorker*. She is the founder and curator of The Drawing Room in Philadelphia.

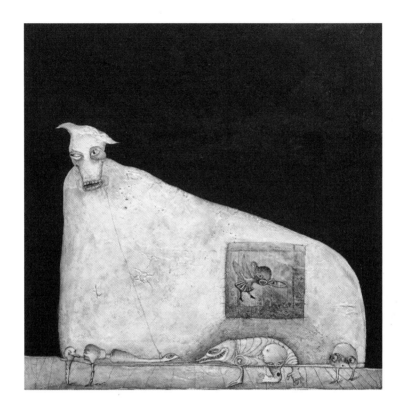

The Quarternote Chapbook Series honors some of the most distinguished poets and prose stylists in contemporary letters and aims to make celebrated writers accessible to all.

Sarabande Books is a nonprofit literary press located in Louisville, KY. Founded in 1994 to champion poetry, short fiction, and essay, we are committed to creating lasting editions that honor exceptional writing. For more information, please visit sarabandebooks.org.